DISPLACED IN DENAN

Jarret Schecter

A SKeGROUP Project ~ Francesca Sorrenti and Mimi O

TROLLEY PUBLISHING

To Dick Young and the people of Denan

DISPLACED IN DENAN

Statistics suggest that there are upwards of 25 million internally displaced people (IDP) in the world, of which the majority come from Africa. Significantly greater in number than refugees, IDP, as the term suggests, are homeless or displaced within their native country. Their internal displacement is most often the result of the recurring and complementary factors of warfare, ethnic violence and extreme poverty. Although the number of IDP approaches that of the population of Canada, a G-8 member and second largest country on the planet, relatively few in the developed world have ever even heard of the term IDP. The following is a story about Denan, and the 10,000 people who live in its IDP camp in southeastern Ethiopia.

The inspiration for my trip to Denan originally began in the apartment of a friend of mine in New York City. It was there that I watched a 14-minute video about this small desert town with a camp for displaced persons in remote southeastern Ethiopia, not far from the border of Somalia. Located in the Ogaden region, it is populated mostly by ethnic Somalis and has been devastated by drought, famine and an armed separatist movement. Temperatures soar daily to well over 110 degrees Fahrenheit, creating some of the most unbearable living conditions in all of Africa. Medical aid is virtually non-existent.

I was so moved by what I'd seen in the film, I felt physically compelled to visit Denan to help its people and capture the place through photographs. After forming a friendship with Dick Young, the Oscar-winning documentarian who'd made the video,

a few of us spearheaded an effort to raise approximately $50,000 to aid the poverty-stricken people there. In the end, most of the money came from a group of men and women in Connecticut who were also touched by the film and its subject. Coming from Woodbury and the surrounding Litchfield County, these twenty men and women named themselves the Denan Committee and solicited donations through grant writing, word of mouth and other creative efforts.

A few months later, I finally made it to Gode, a town situated 42 miles away from Denan. While I was all too aware of the area's abject poverty, I had not thought too much about the geopolitical problems. It was then that I saw a group of largely uneducated Muslim men hovering over a television set in which the channels were constantly switched between Al Jazeera and CNN. Intensely

religious, highly impoverished and with easy access to satellite television and its inflammatory and conflicting images, this region is very similar to other areas of the world. It, too, is a powder keg for violence and terrorism. In addition to these combustible elements, this area of southeastern Ethiopia is also adjacent to the porous border of lawless Somalia, which in turn is close to Yemen, Saudi Arabia and other countries in the Middle East with militantly Islamic elements. That was the day I truly recognized the invaluable link between humanitarian affairs and global security. It was also the day I felt more anxious than ever that the U.S. and the developed world was doing far too little to acknowledge this connection.

After a 42-mile, two-hour trek through the desert, Dick Young and I arrived in Denan. Accompanied by a Sudanese-trained doctor, equipped with various medicines and a solar-powered water filtration kit, we were excited to be part of a small mission that was going to save lives. It quickly became apparent, though, that our mission wasn't going to be so small. By 8am, there were already five hundred refugees waiting for treatment at the dilapidated building that was to serve as the medical center.

Photographing the crowded scene on the first day at the makeshift clinic in the 108-degree heat was overwhelming. Within just a few hours, I had seen scores of severely malnourished children with tuberculosis, polio and other life-threatening afflictions. I felt guilty then (and still do), but I was more than a little aware of my own discomfort and desire for some of the creature comforts I was used to in New York. Ultimately, though, I was content to be there and happy to help our doctor who heroically spent hour after hour taking care of his desperate, but grateful patients. From dispensing basic antibiotics, to setting bones, to offering words of comfort, he tended to every last person in line.

As a photographer, I was inspired by the endless vistas and spectacular emptiness. And in the middle of this emptiness, there was the unforgettable sight of the refugee camp with its teeming life in colorful garb darting here and there underneath the shifting skies.

After two gruelling non-stop days, we set off for Addis Ababa, the capital of Ethiopia. I was physically and mentally exhausted and more than happy to leave Denan. However, three weeks later, typing away in my studio apartment in New York, I realize that I miss the place. I am also grateful to remember so many of the faces that I saw at the clinic, especially the children.

Today, besides the memorable imagery of the people and landscape, I think about the potential for positive change. Beginning with the noble conscience of a single filmmaker, a town in Connecticut was able to secure $50,000 for an impoverished outpost in Ethiopia and still continues its efforts to help this region. If these acts of generosity were replicated on a vast scale throughout America, the consequences would be immeasurable for those who need help and for those doing the helping. America's standing in the world could use some bolstering and a little more selfless charity on its part might go a long way. Fortunately there are people like Dick Young and the Denan Committee who, through their ingenuity, persistence and generosity, are finding ways to make the world a more harmonious place for everyone.
–Jarret Schecter

The Denan Project (www.thedenanproject.com) was founded to provide quality medical care to the people of Denan, Ethiopia, for the first time.

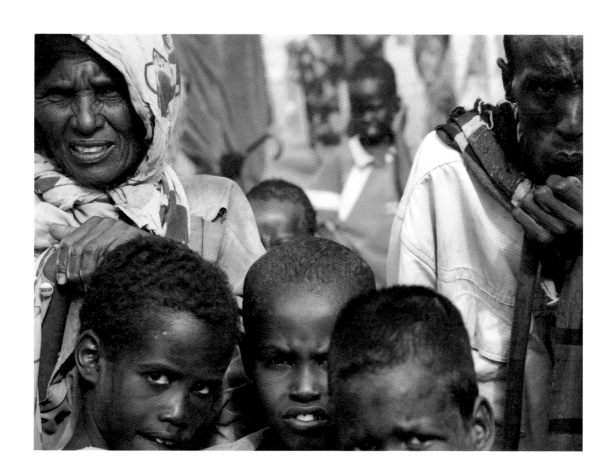

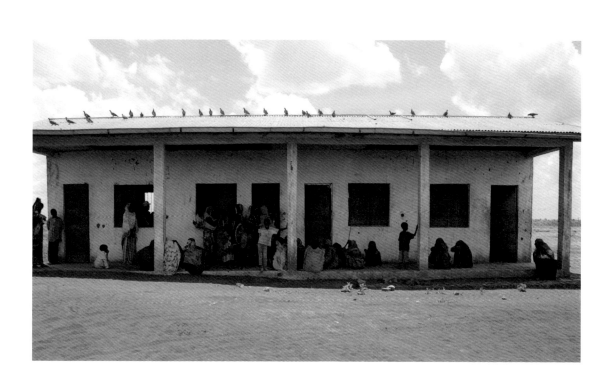

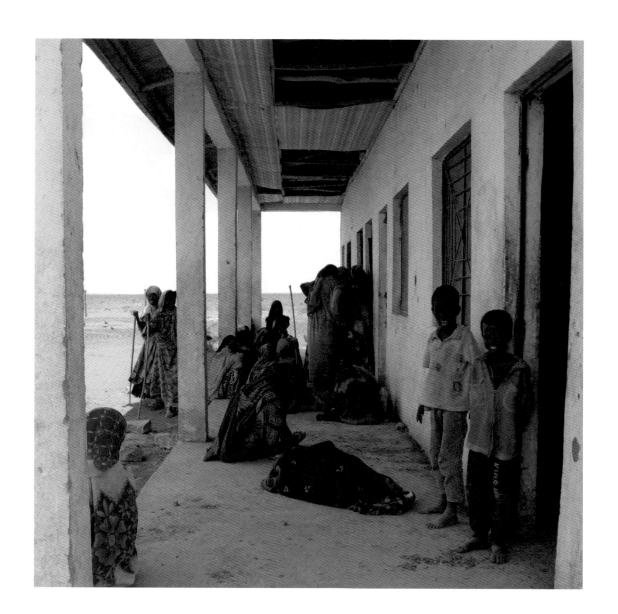

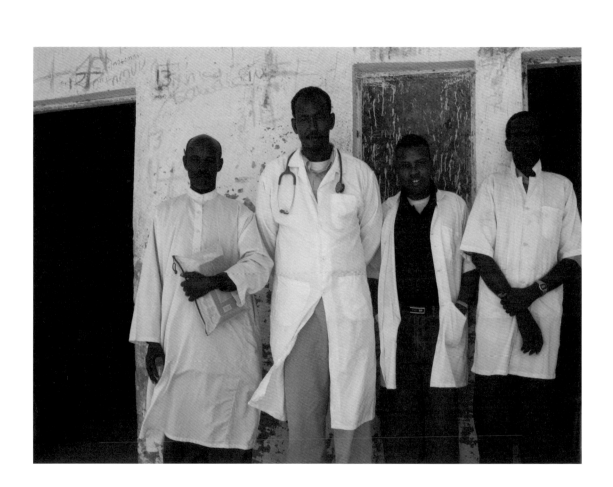

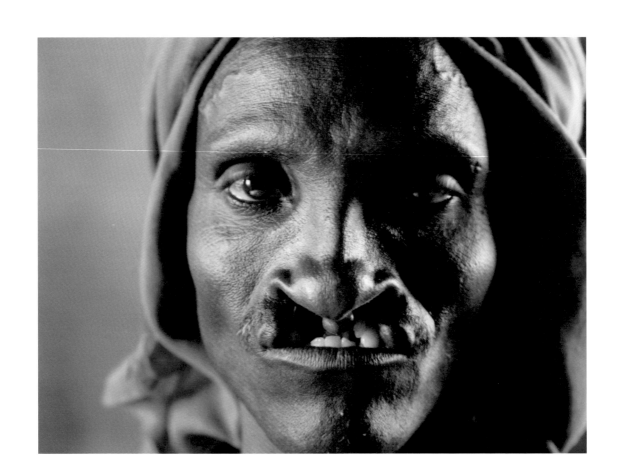

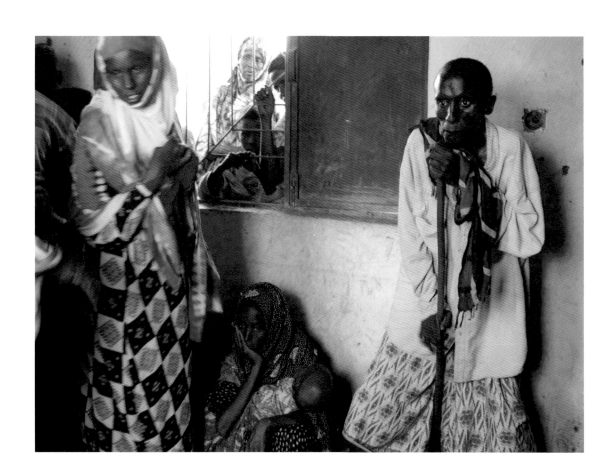

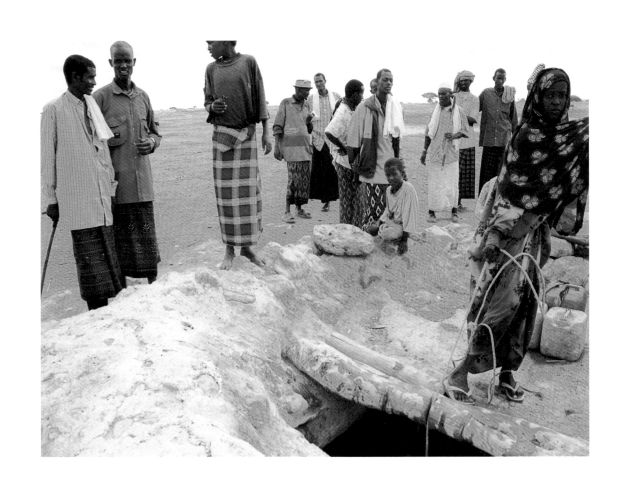

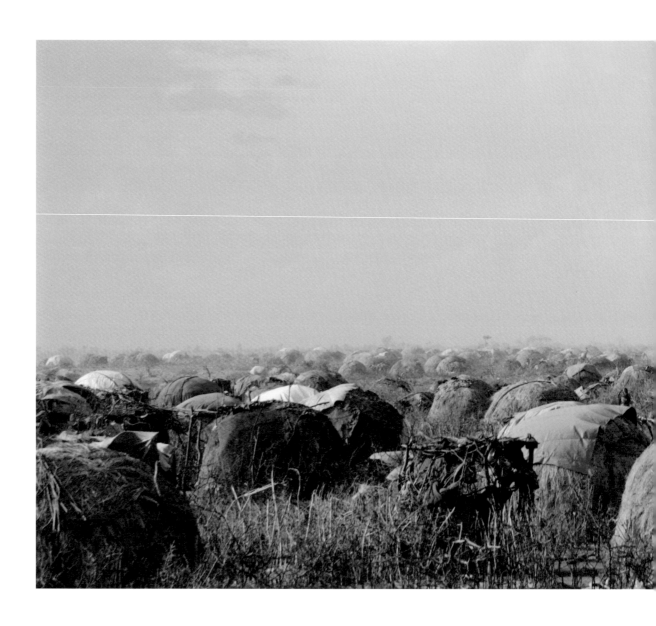

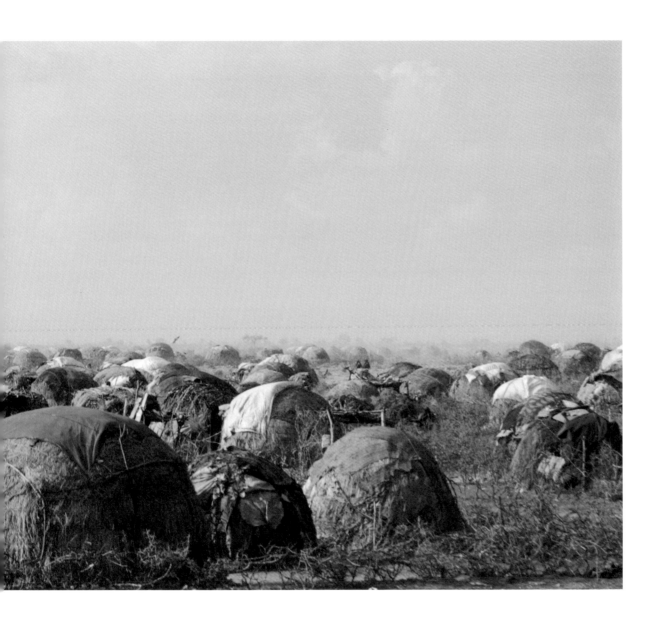

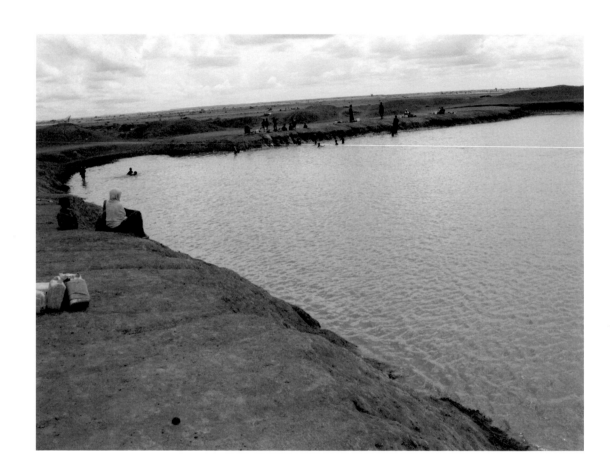

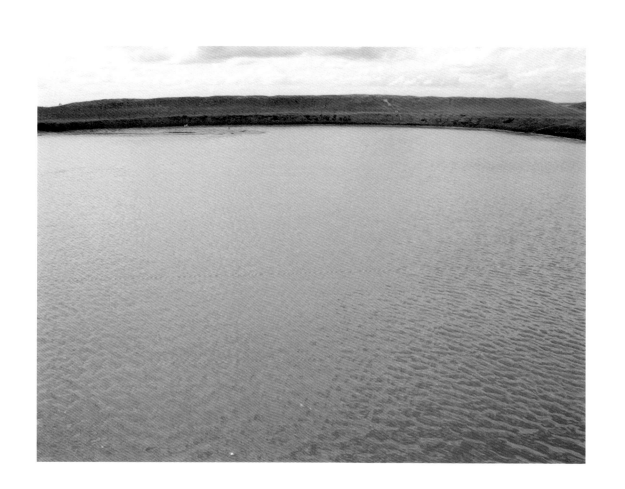

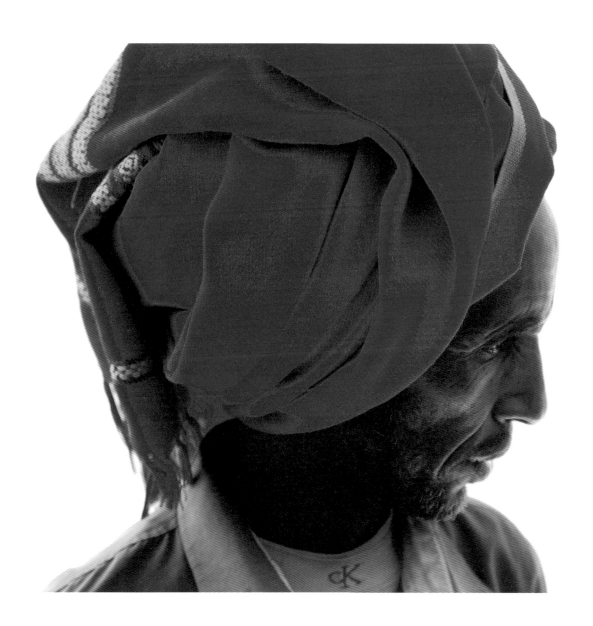

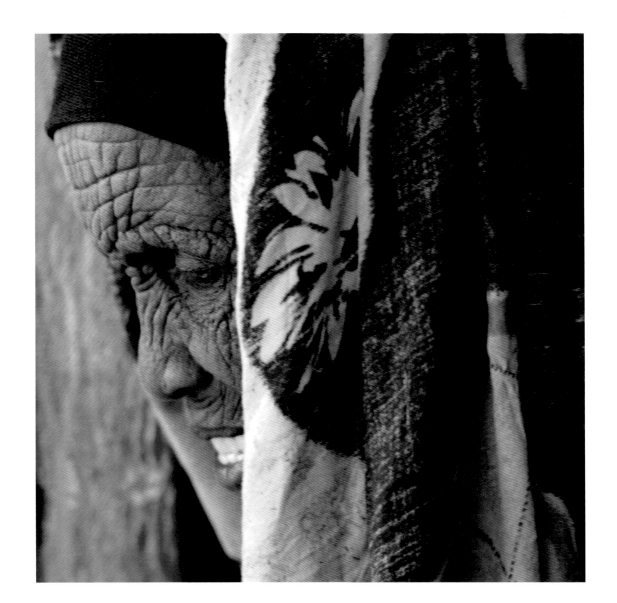

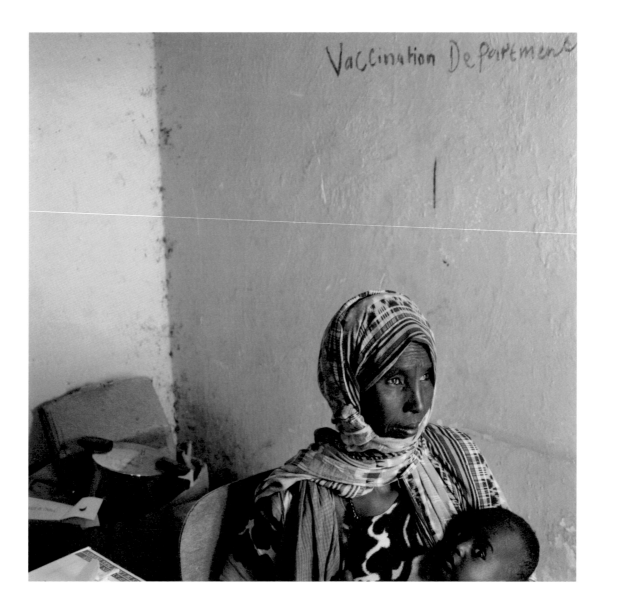

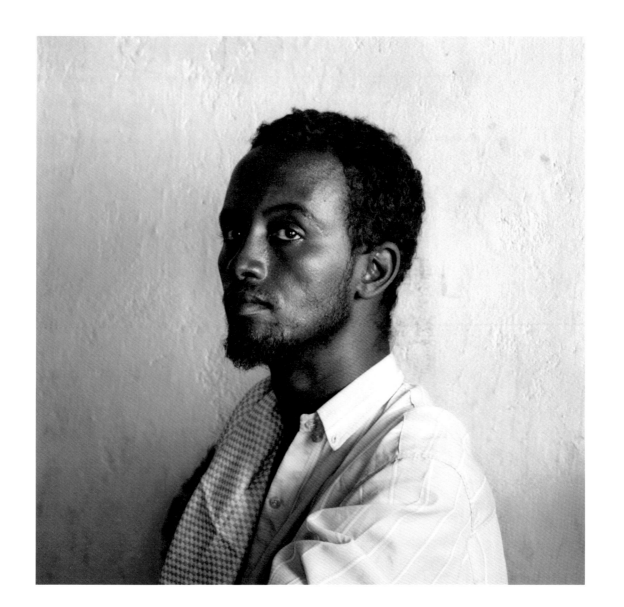

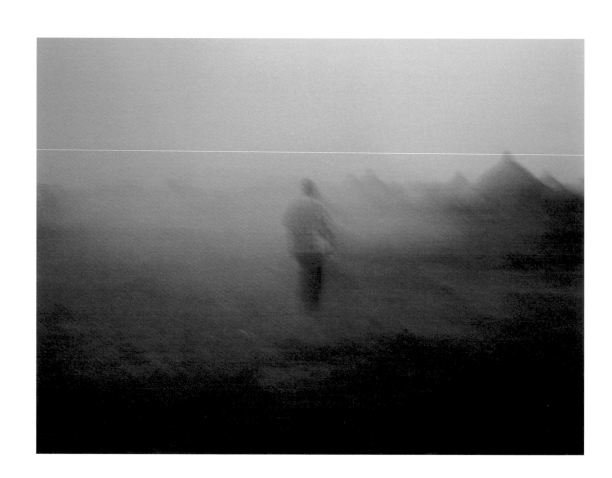

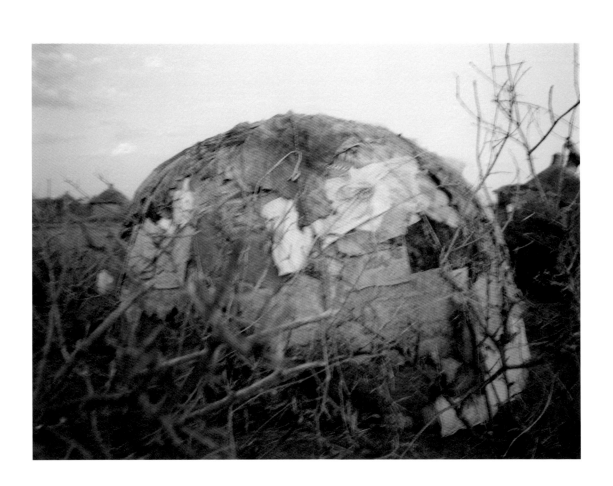

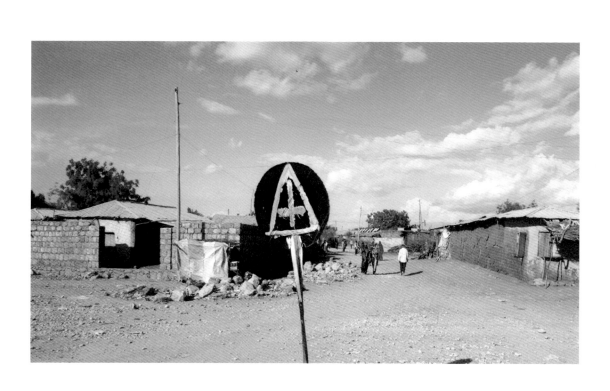

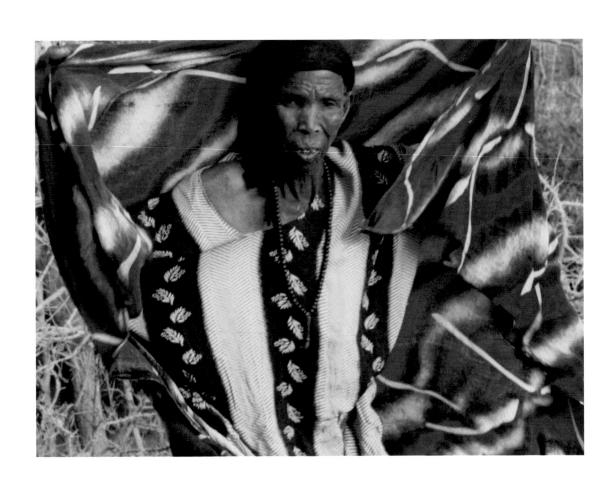

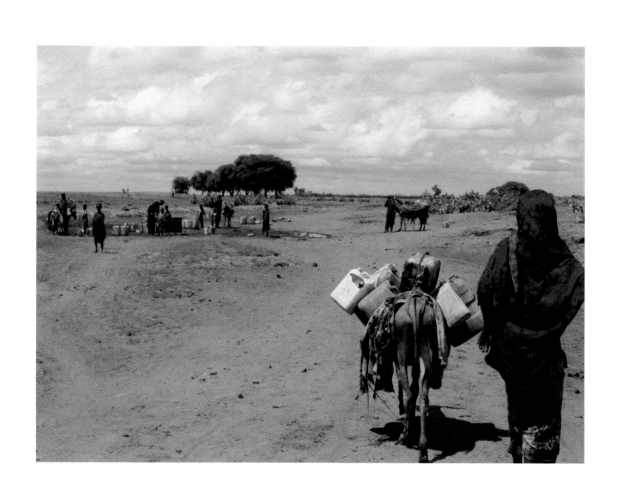

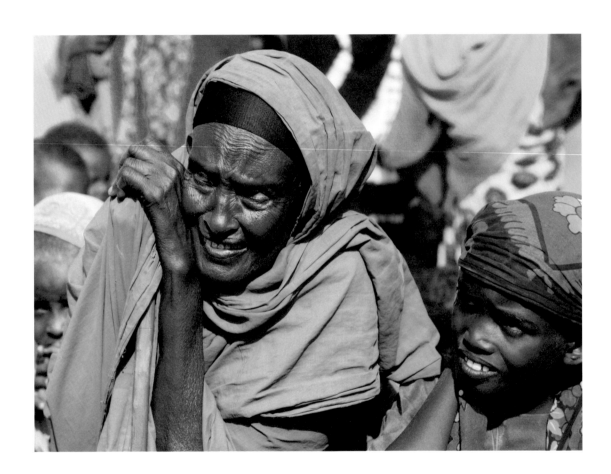

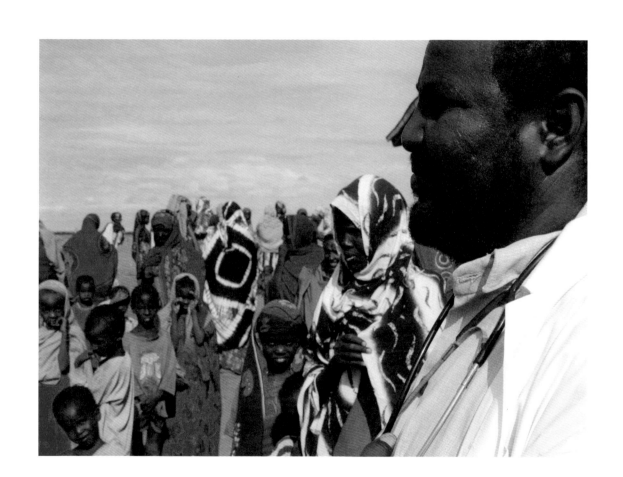

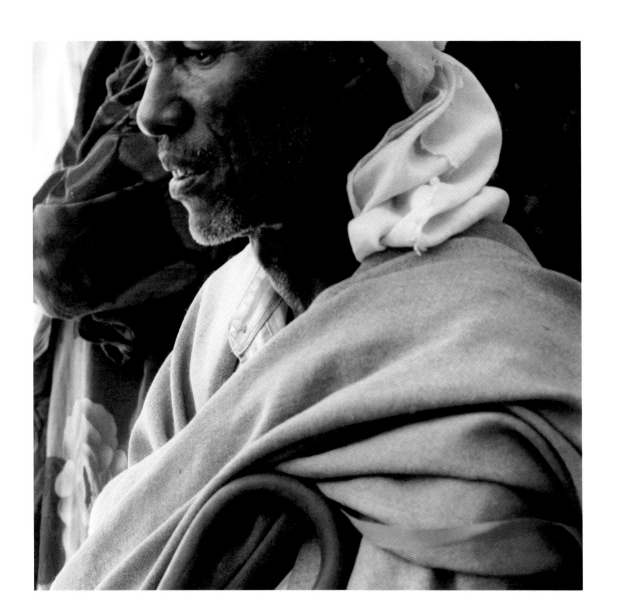

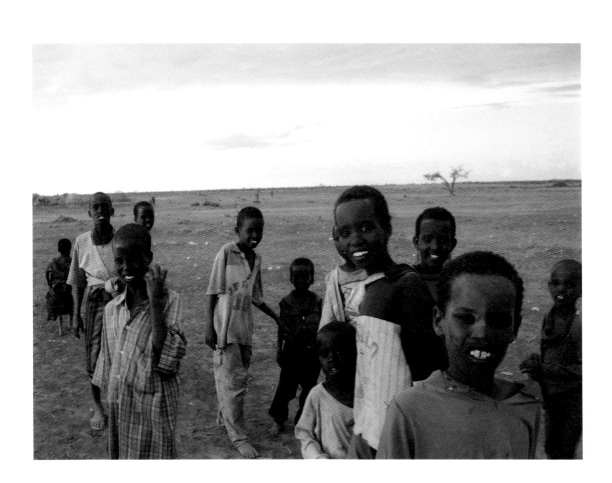

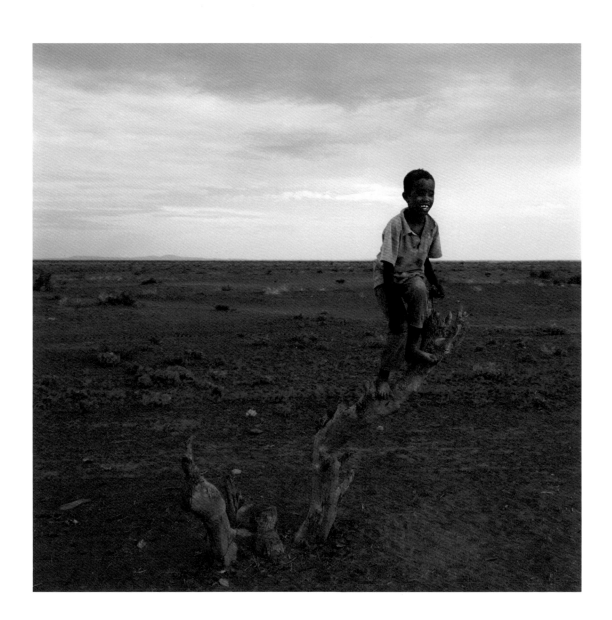

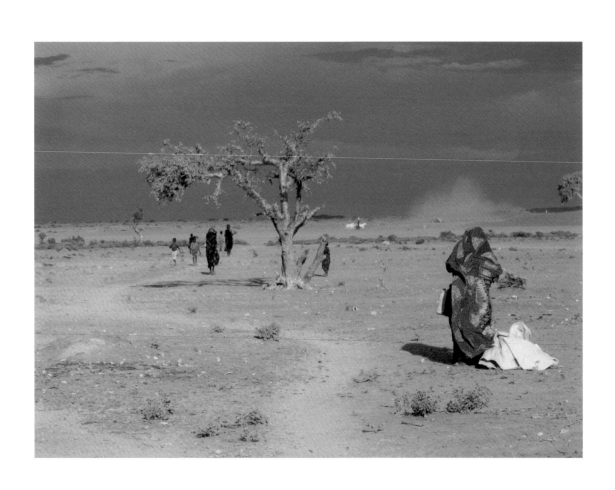

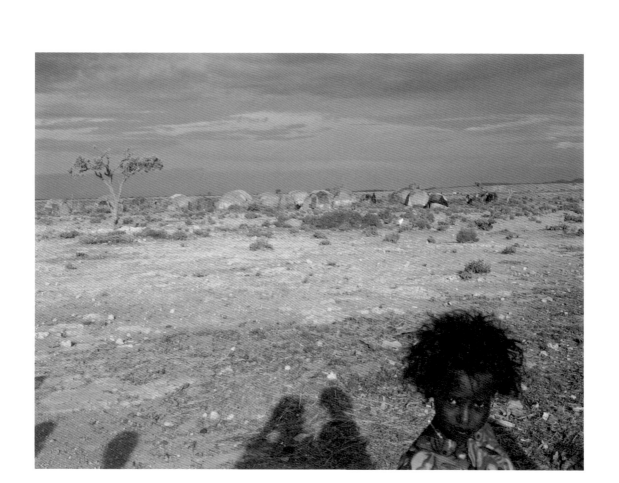

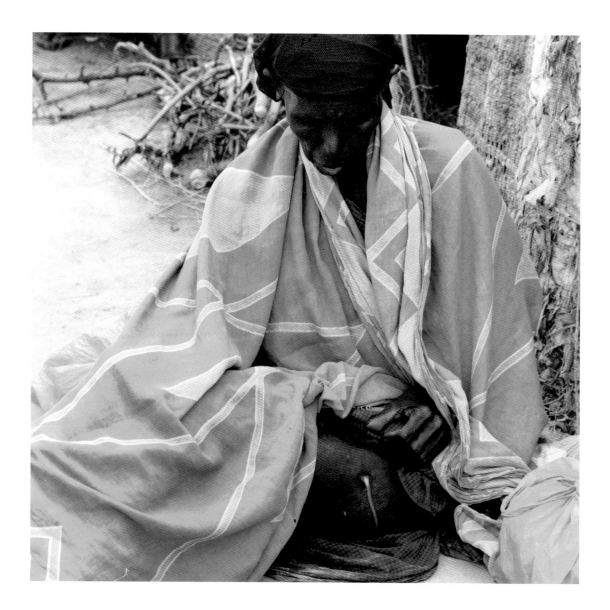

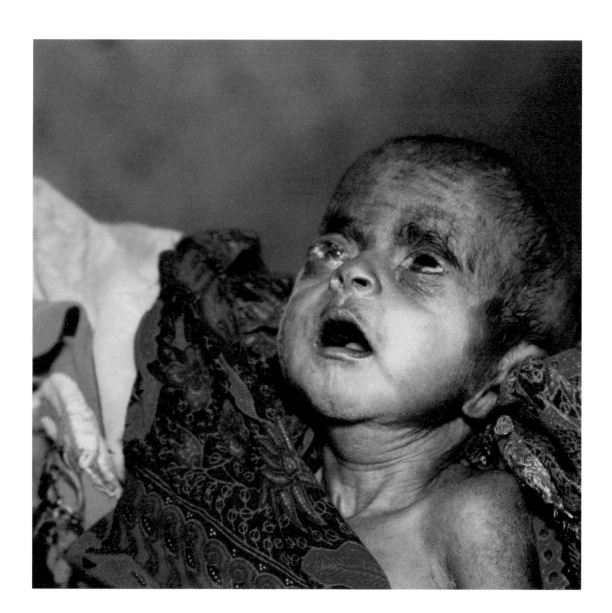

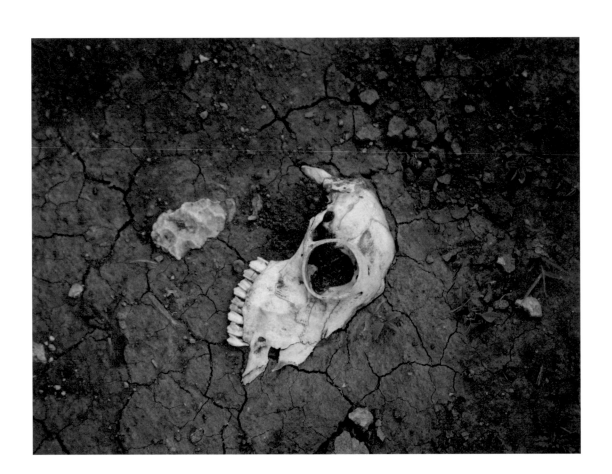

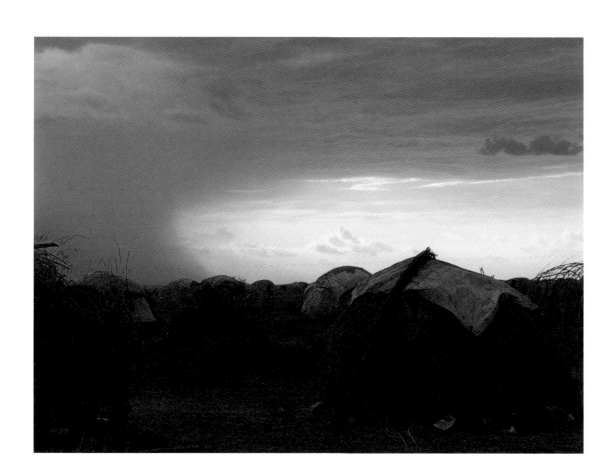

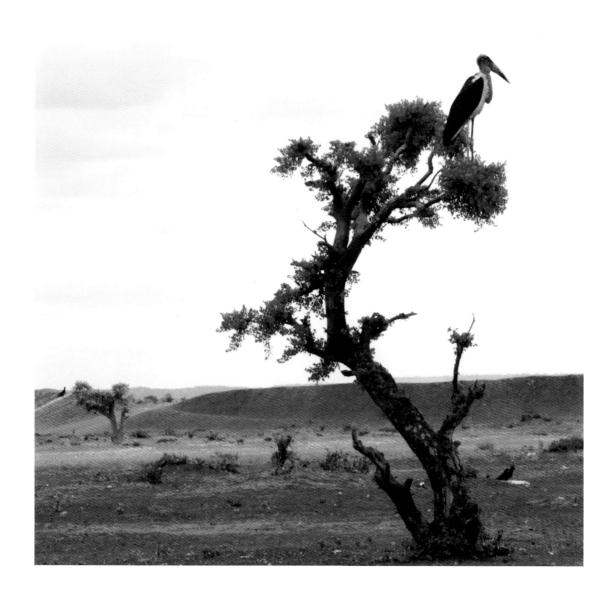

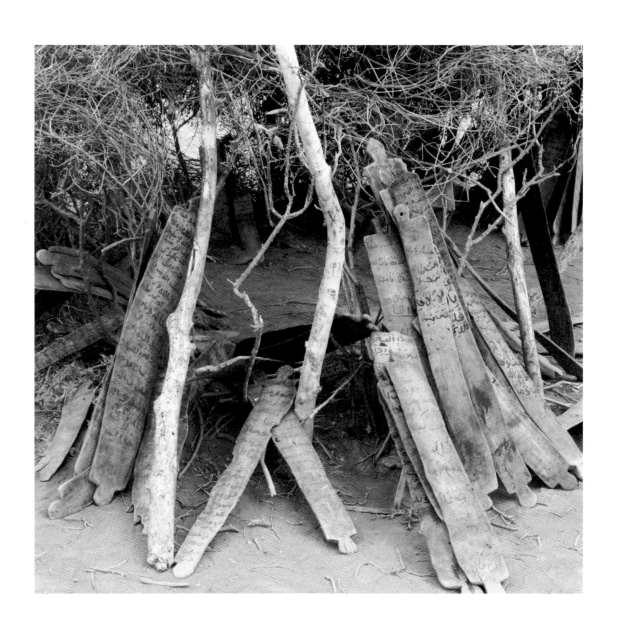

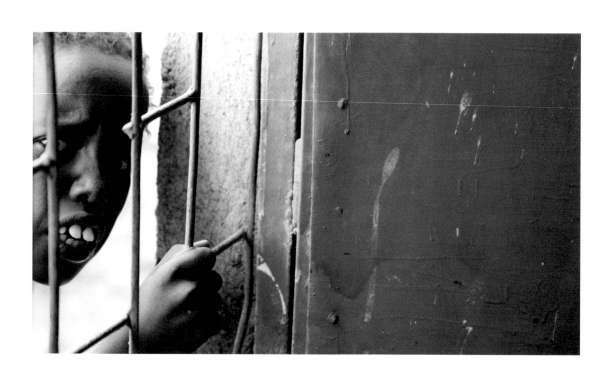

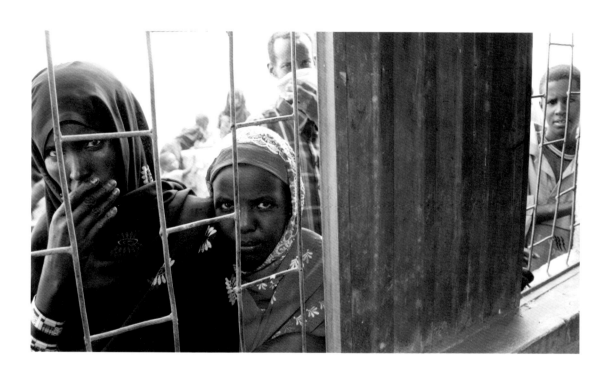

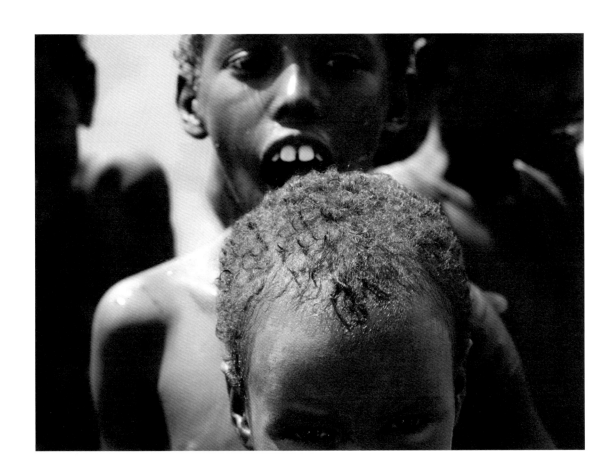

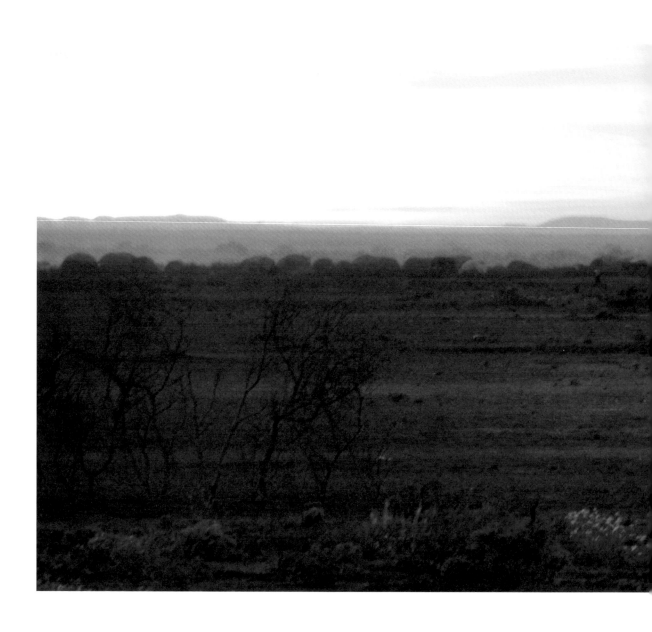

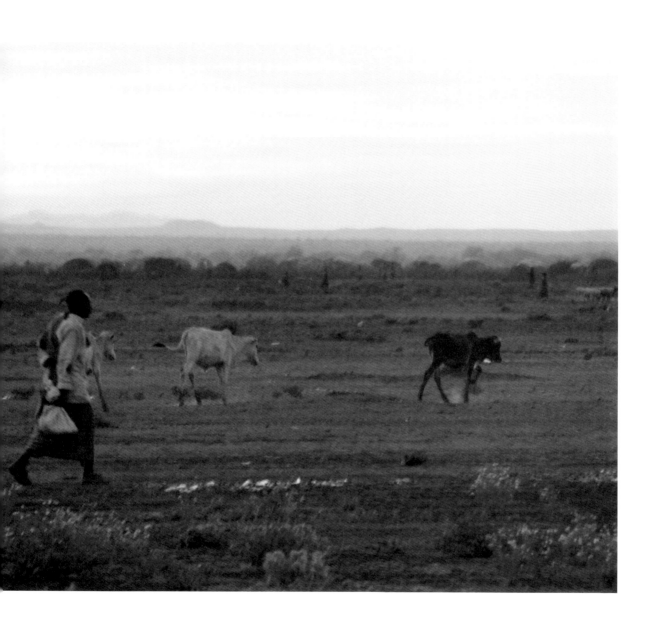

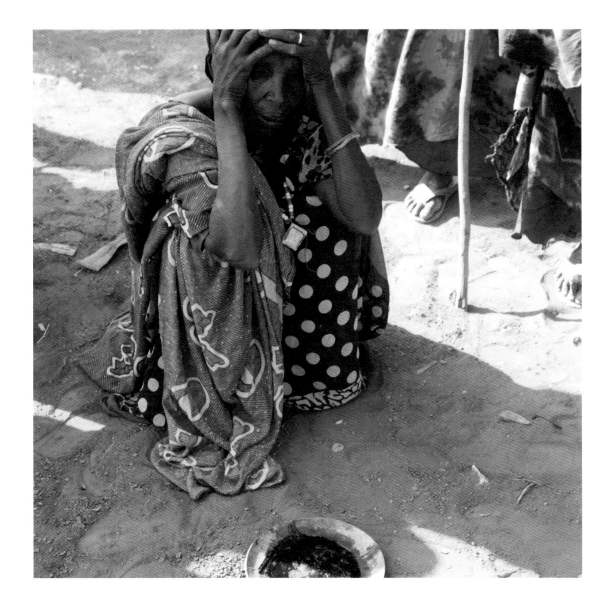

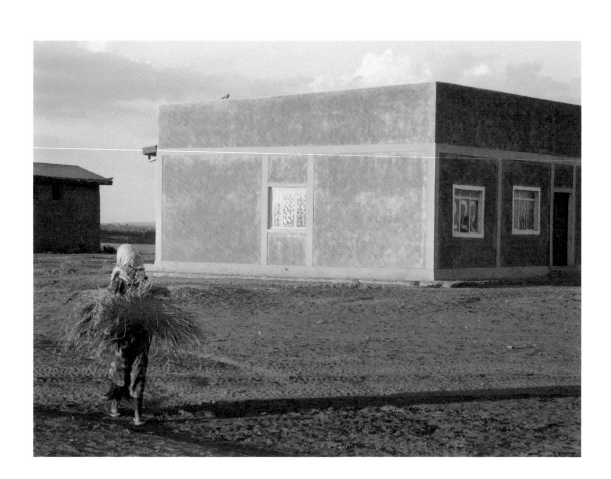

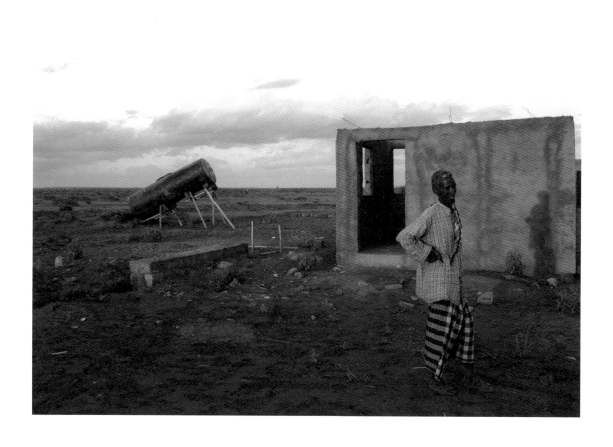

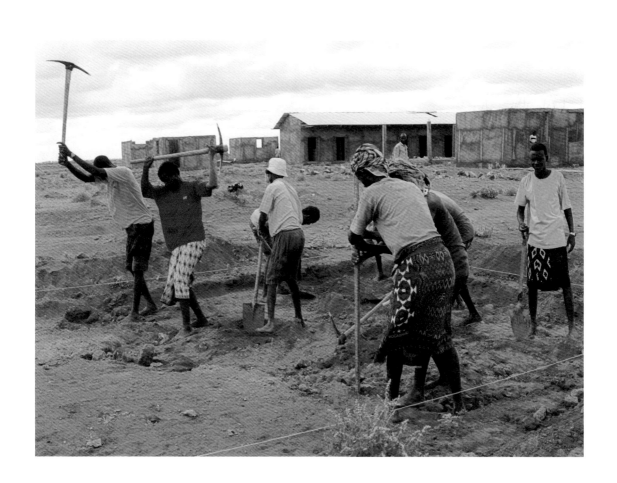

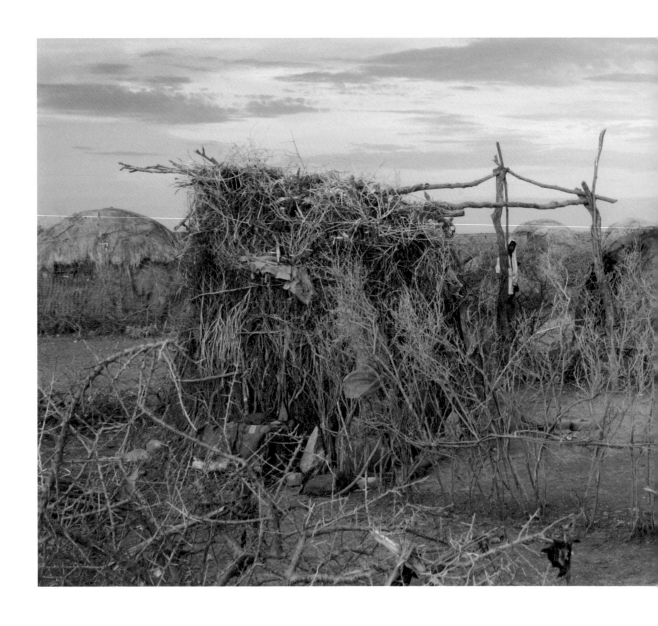

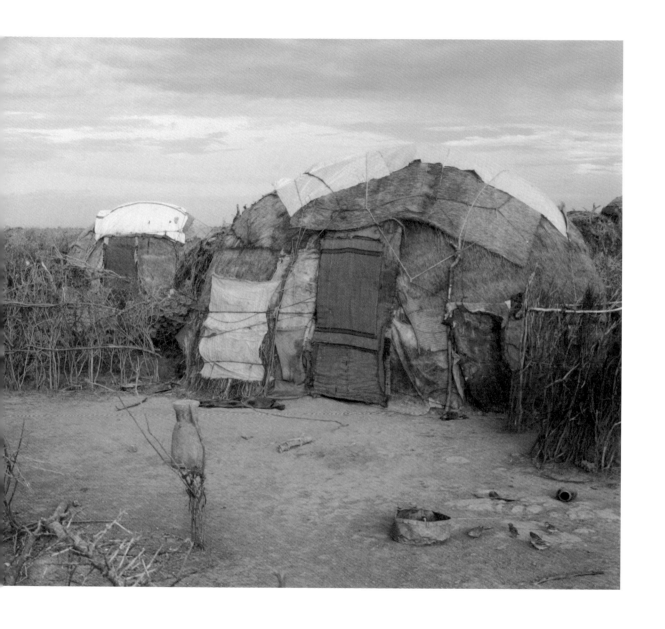

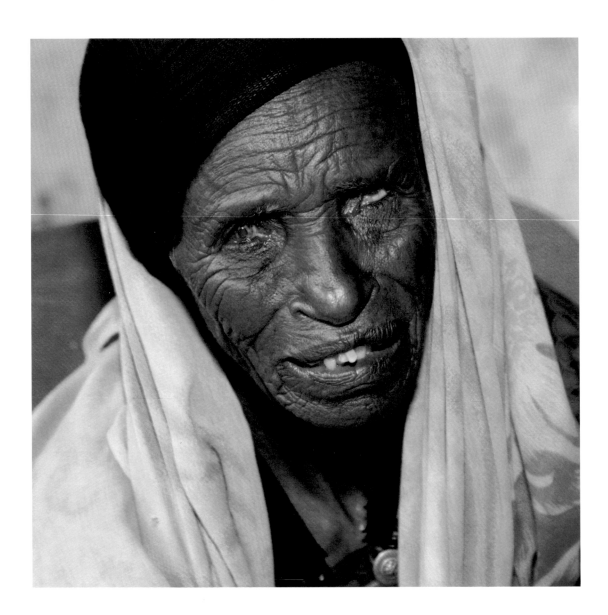

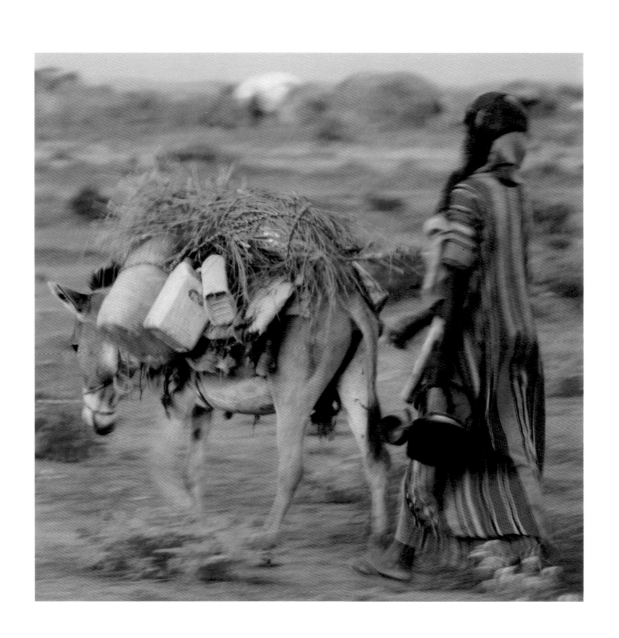

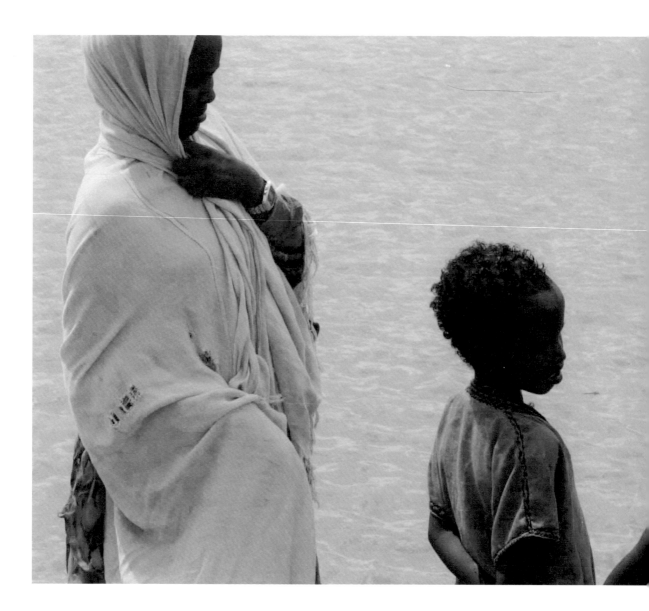

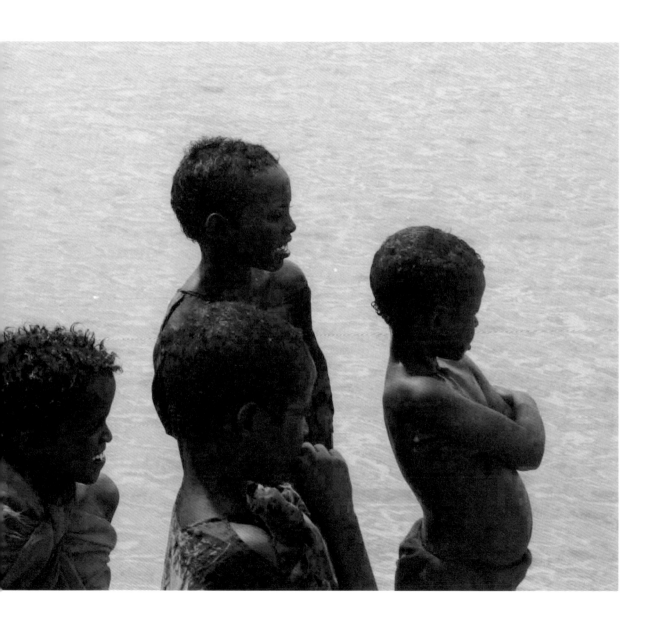

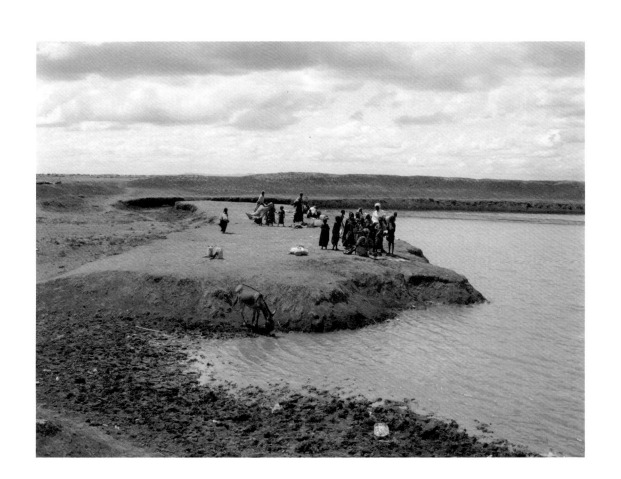

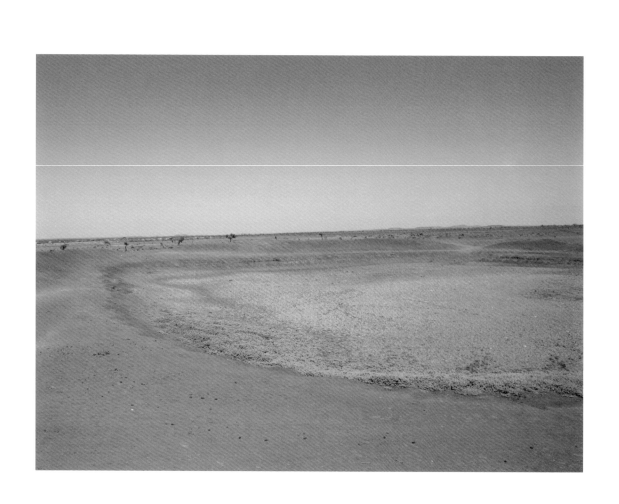

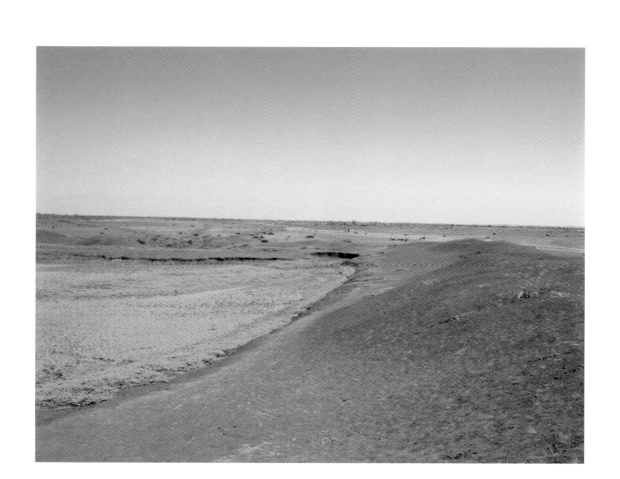

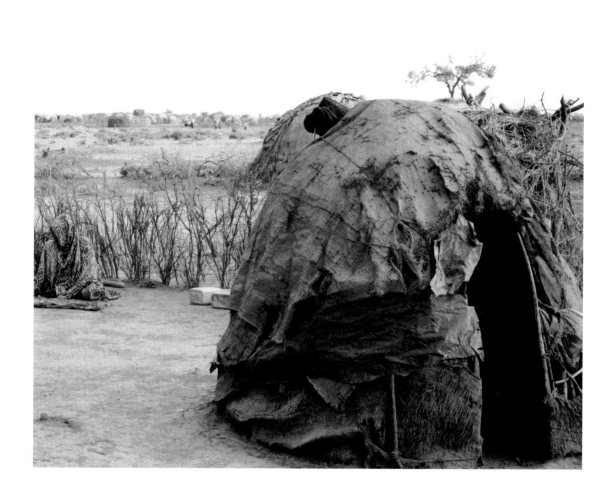

Acknowledgments

A very special thanks

Dr. Sadik Mohamed
Mukhtar Shekomer
Ambassador Mohammud Dirir
The late ambassador
Abdulmejid Hussein
Marisha Shibuya
Beshir Abdulahi
Sisay Gadlu
Rashid Omer
and the whole OWDA team
Tamru & Seniat
Jerry Butler
Walt Dierks
Sue Dierks
Hilda Hetherington
Mark Genest
John Moisan

Kathy Owens
Linda Silverstein
Morton Silverstein
Charles Stauffacher
Eileen Stephens
Duncan Stephens
Hiro Shibuya
Marvin & Marian
Darrow & Diana
Francis
Kristyna Navratilova
Jason Liu
Larry Hurtado
Jake McCabe
Davide
Gigi Giannuzzi
Valentina Petrelli

Credits

Photographer
Jarret Schecter
Creative director /
Photography editor
Francesca Sorrenti
Art director /
Associate photography editor
Mimi O
Office In Concept (NYC)
Text editor
David Cashion
Retouching
Statik Digital
www.statikdigital.com
Project assistant
Francesca Cerchione

About the photographer In 1990 Jarret Schecter purchased a professional Pentax camera and a passion was born. He decided to travel the world and just "take pictures", but along the way he saw people living in unspeakable conditions of poverty. Schecter always had an interest in socio-political issues and believes that poverty is the biggest injustice to mankind. Schecter feels that with his photography and through his books he can bring awareness to social injustices that the world faces today. Jarret Schecter, born in 1963, lives in New York City and continues his extensive travels to developing countries, documenting the poverty-ridden regions he visits.

About SKeGROUP In 2003, Francesca Sorrenti created, with Marisha Shibuya, SKeGROUP. Their aim is to bring awareness to environmental, social and ethical issues through the arts by uniting photographers, writers and designers to work on special book projects. A portion of the book proceeds benefits our partnering organizations and the books are used as an educational and promotional tool for the organizations that SKeGROUP supports. Francesca Sorrenti lives in Brooklyn, New York and Marisha Shibuya lives in Bangkok.
SKeGROUP – info@skegroup.com

Published in Great Britain in 2005
by Trolley Ltd.,
73a Redchurch Street,
London E2 7DJ, UK

© Jarret Schecter, 2005

10 9 8 7 6 5 4 3 2 1

A catalogue record for this book is
available from the British Library

ISBN 1-904563-47-3

Design by Mimi O at Office In
Concept (NYC) and Francesca Sorrenti

Printed in Italy by Soso Industrie
Grafiche Spa